"DOGS NEVER BITE ME. JUST HUMANS"

MARILYN MONROE

INSTA GRAMMAR
DOGS

LANNOO

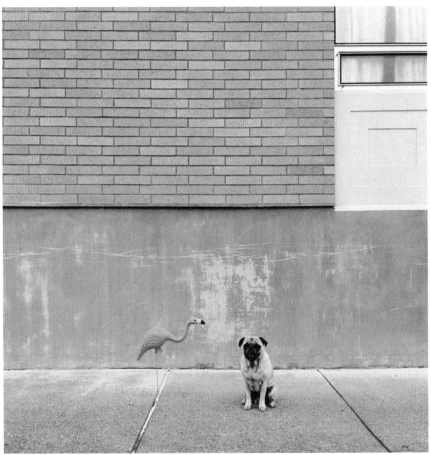

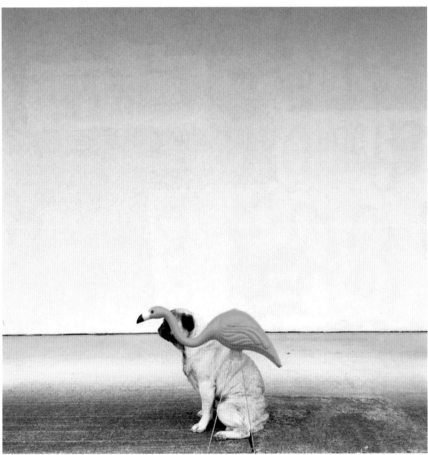

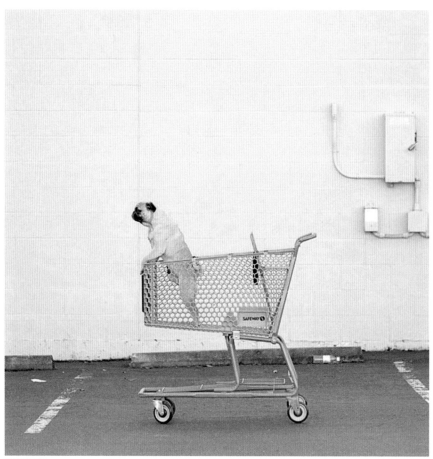

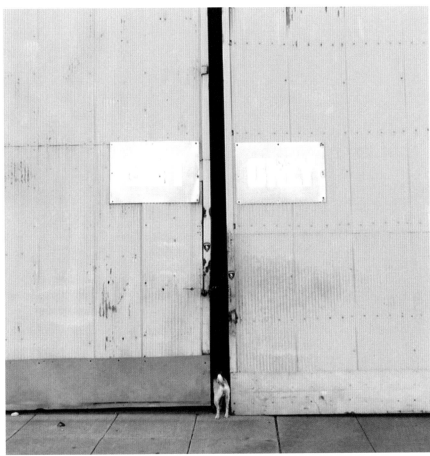

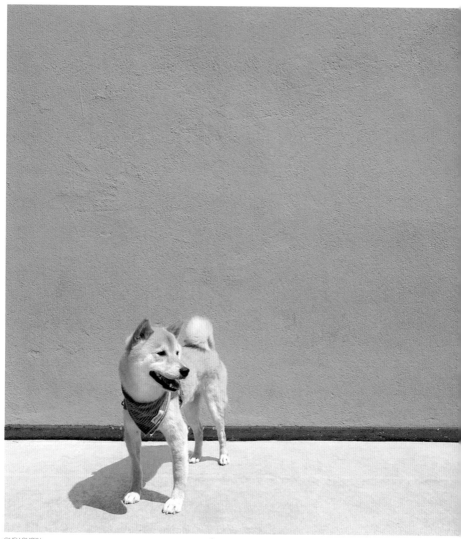

"PEOPLE LOVE DOGS. YOU CAN NEVER GO WRONG ADDING A DOG TO THE STORY."

JIM BUTCHER

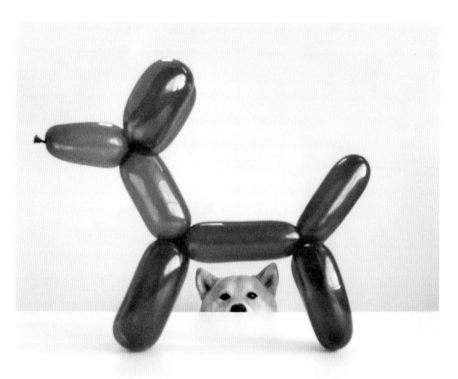

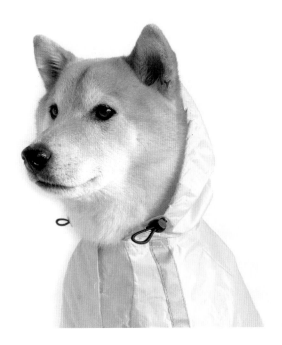

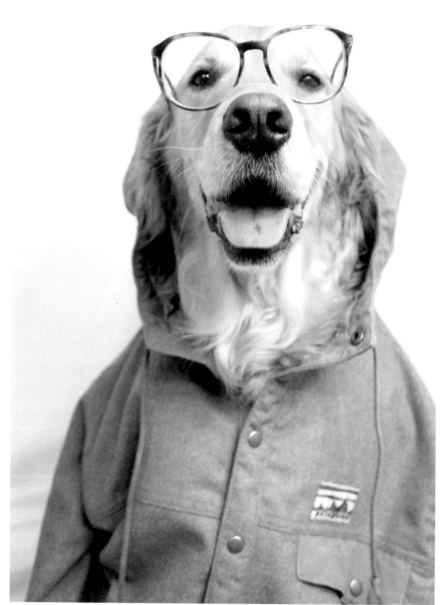

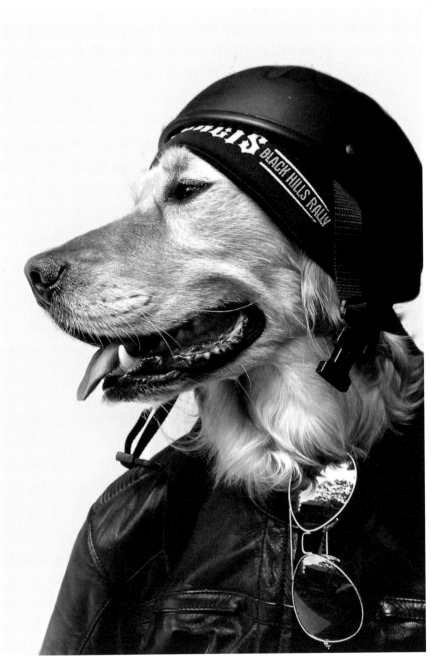

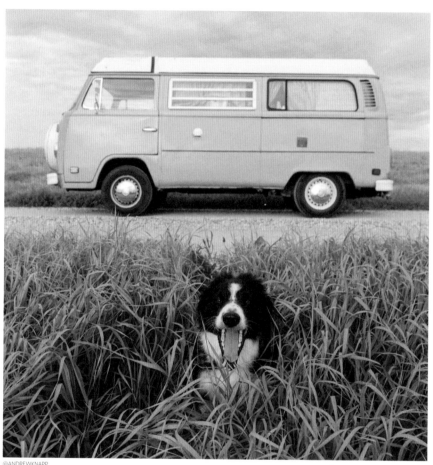

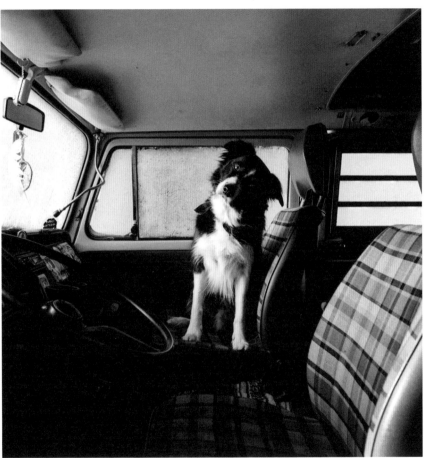

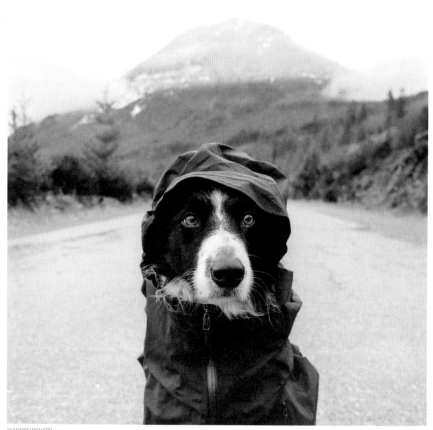

"BE YOUR OWN DOG, DON'T LET NOBODY PUT A LEASH ON YOU"

DEUS

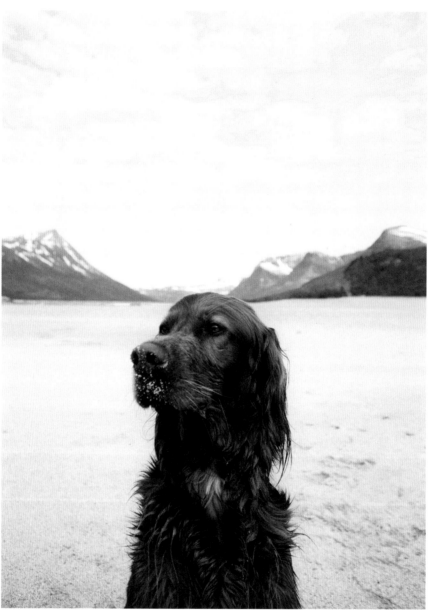

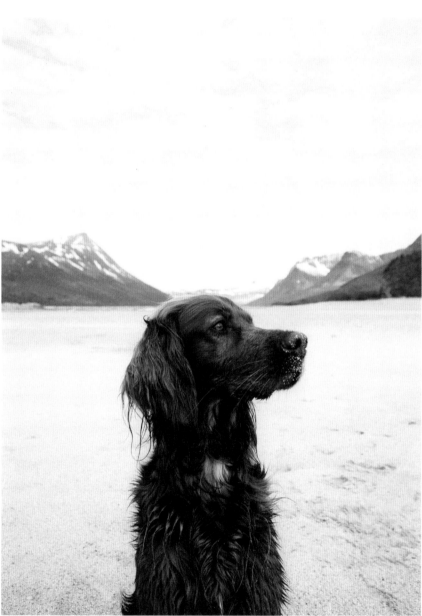

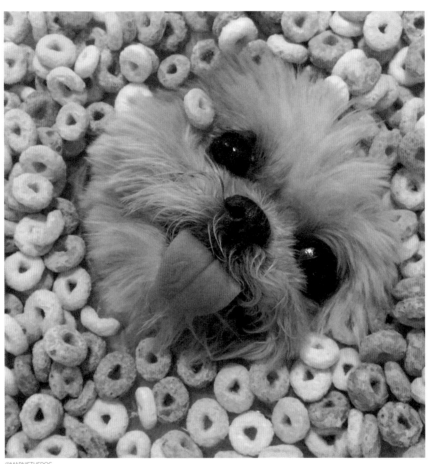

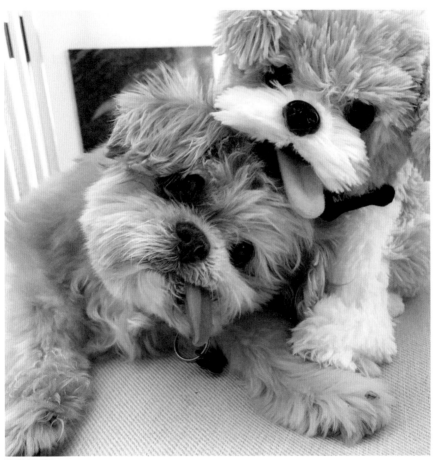

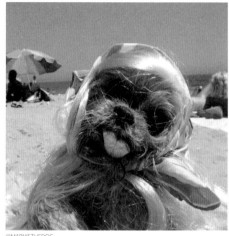

@MARNIETHEDOG

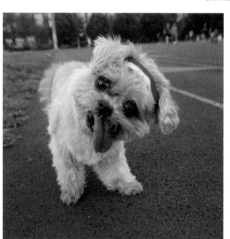

@MARNIETHEDOG

@MARNIETHEDOG

"WHO LET THE DOGS OUT?"

BAHA MEN

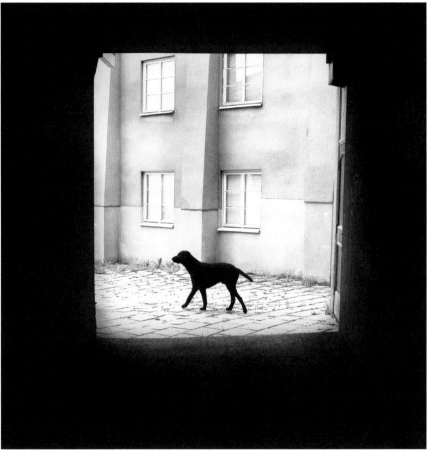

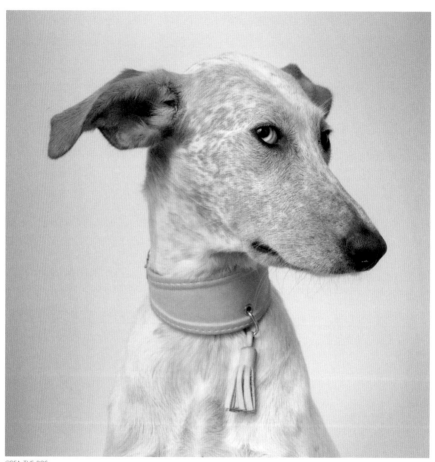

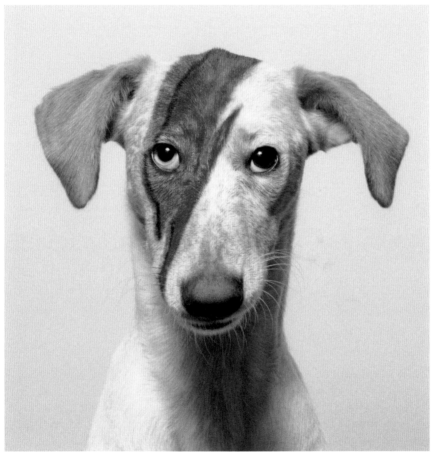

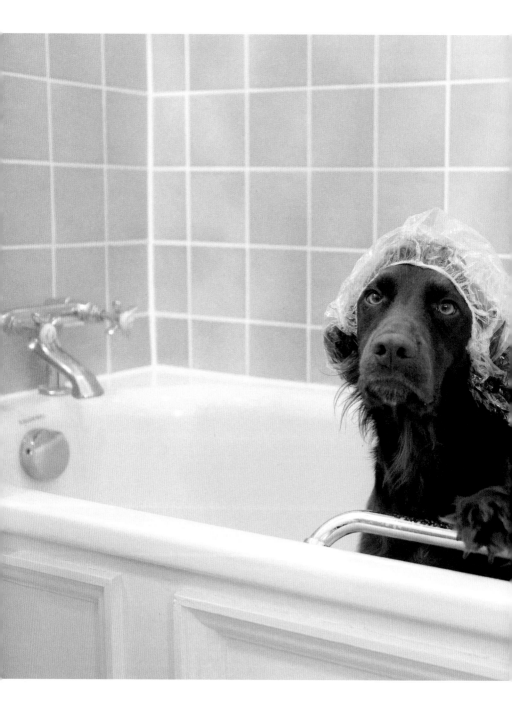

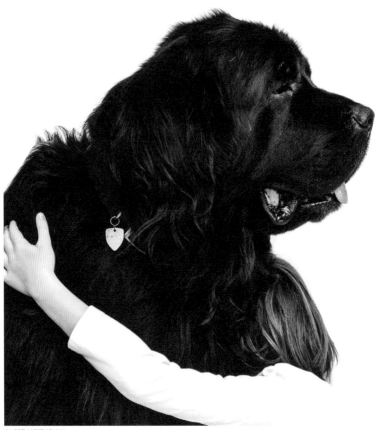

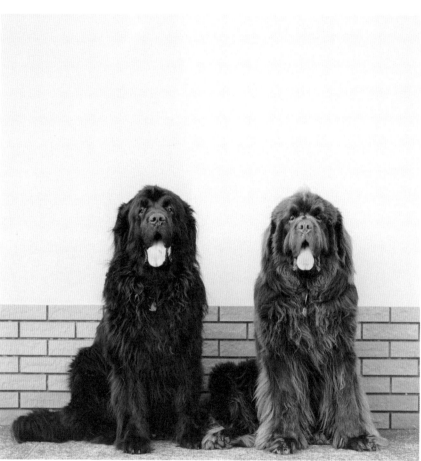

"THE LOVE OF A DOG IS A PURE THING. HE GIVES YOU A TRUST WHICH IS TOTAL."

MICHEL HOUELLEBECQ

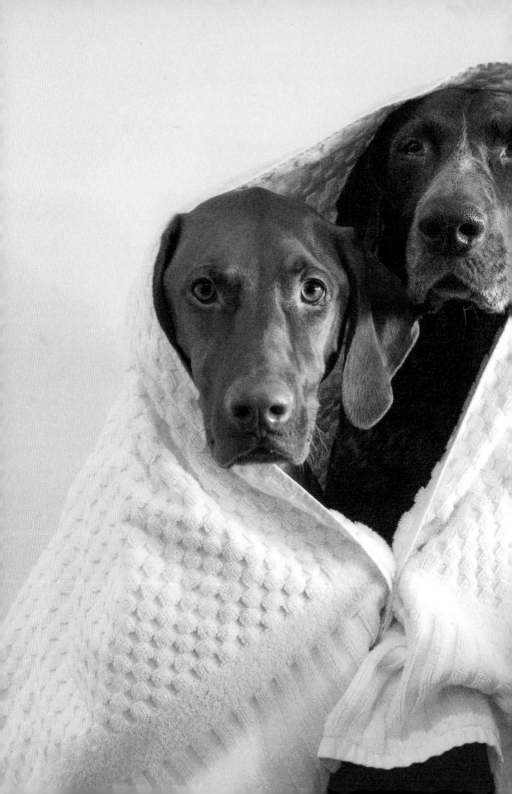

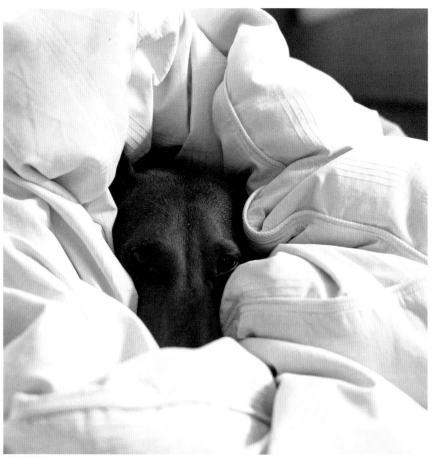
@HOMERHUND

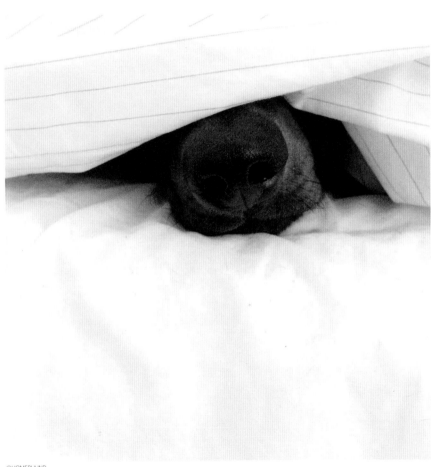

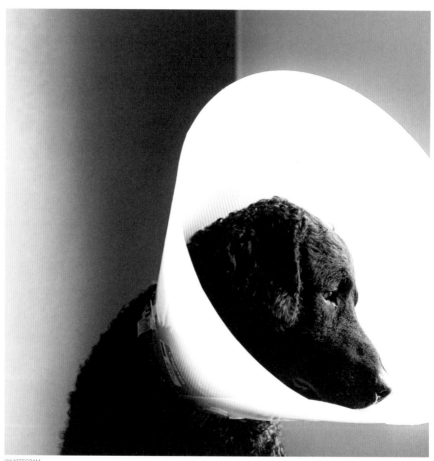

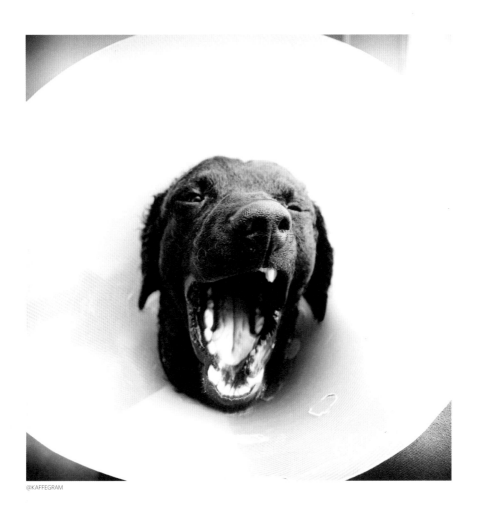

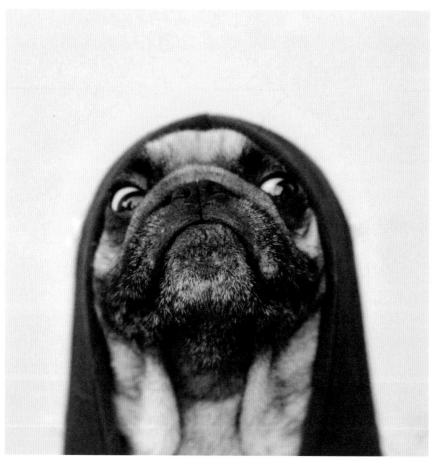

"IT'S NOT THE SIZE OF THE DOG IN THE FIGHT, IT'S THE SIZE OF THE FIGHT IN THE DOG."

MARK TWAIN

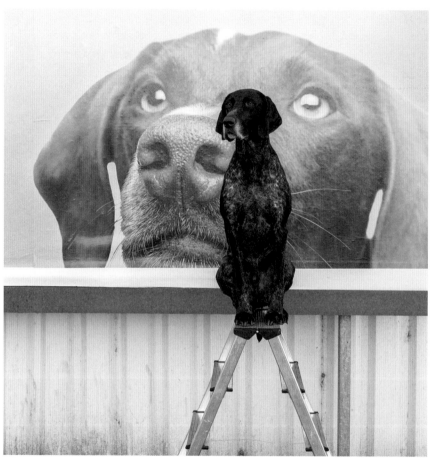

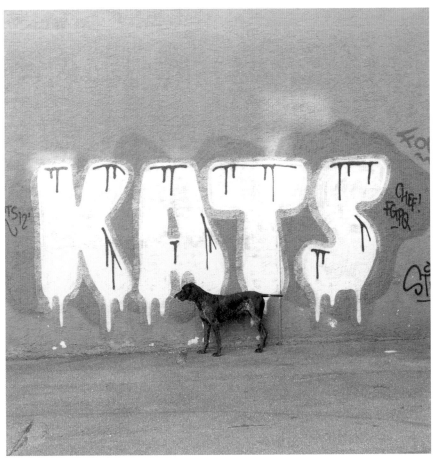

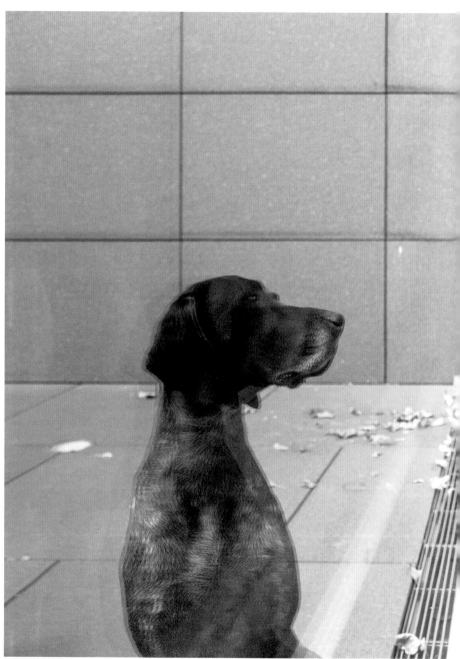

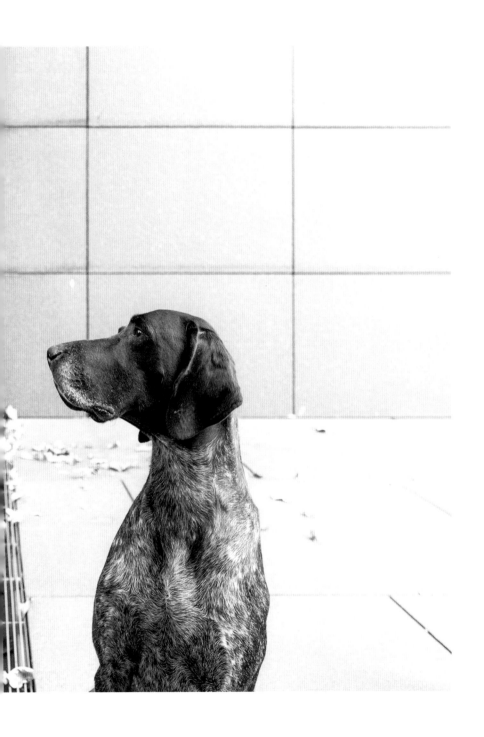

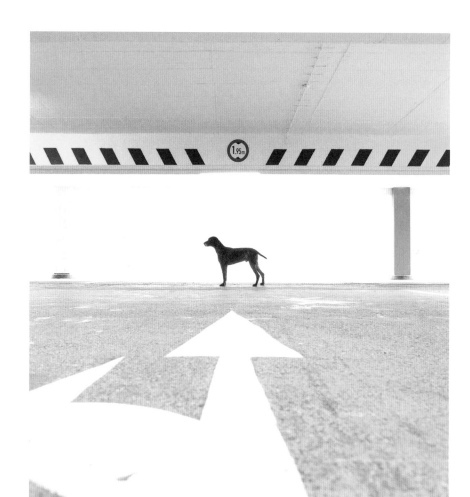

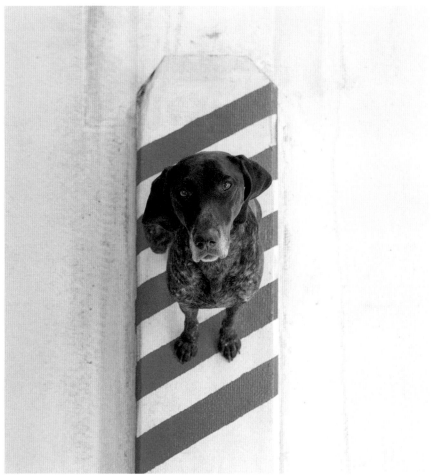

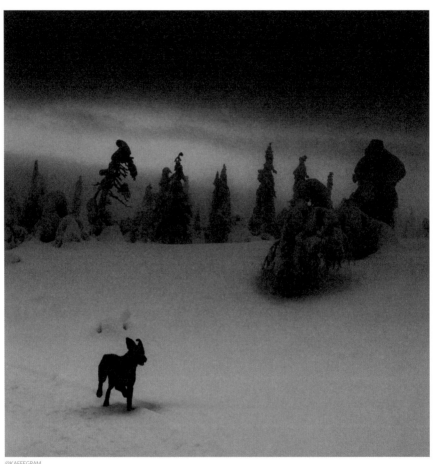

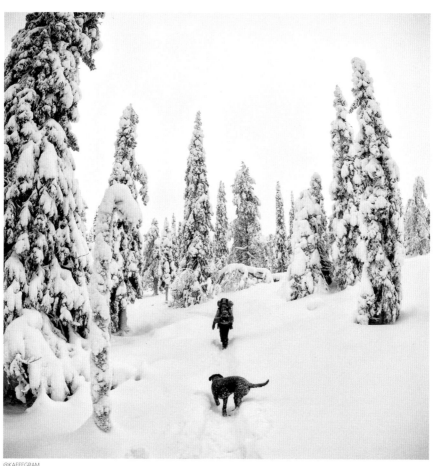

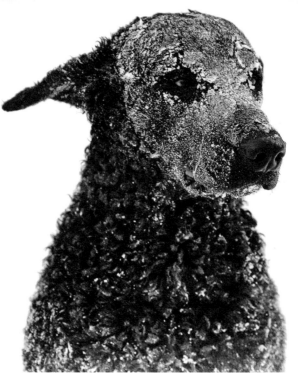

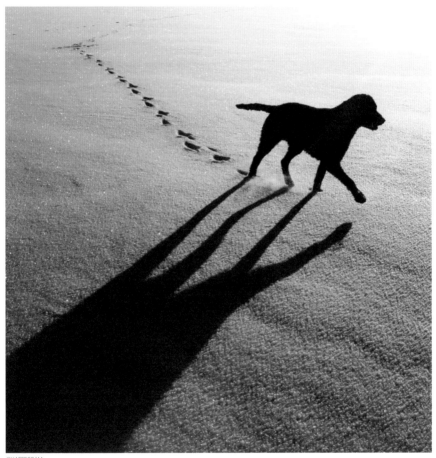

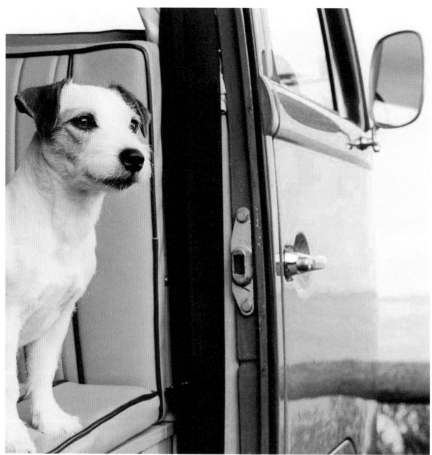

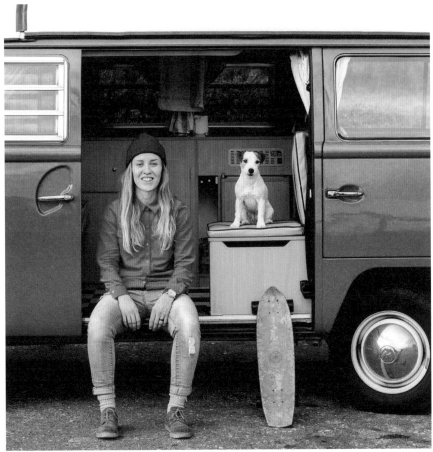

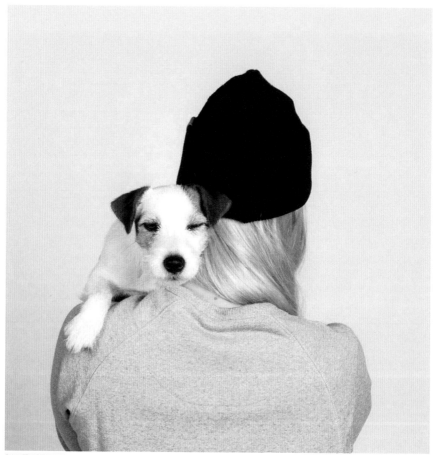

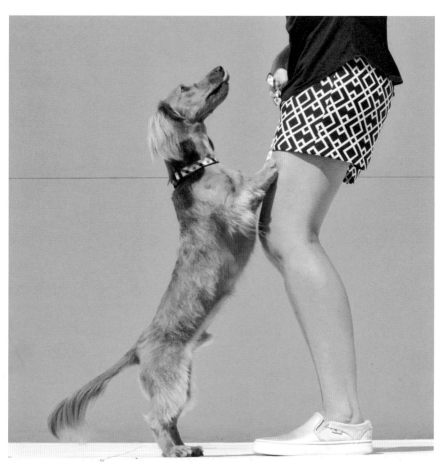

@DJANGO_AND_CHLOE

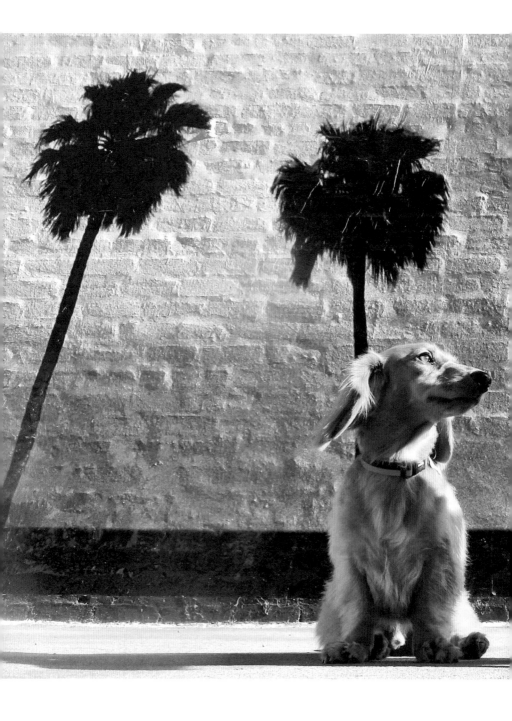

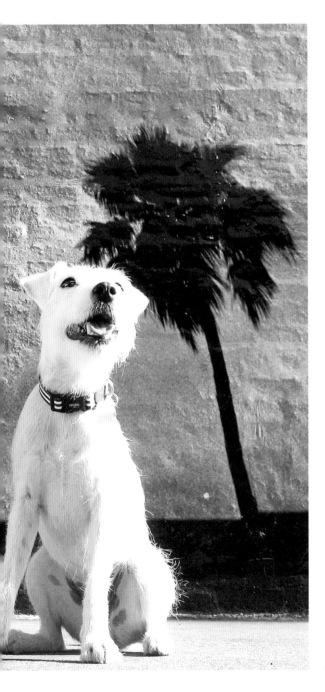

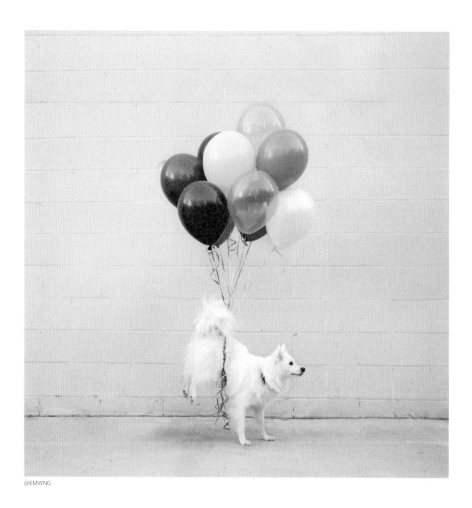

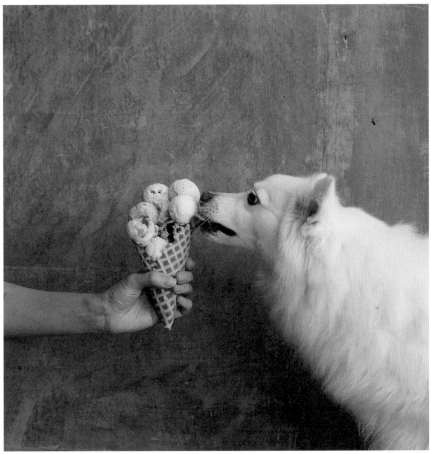

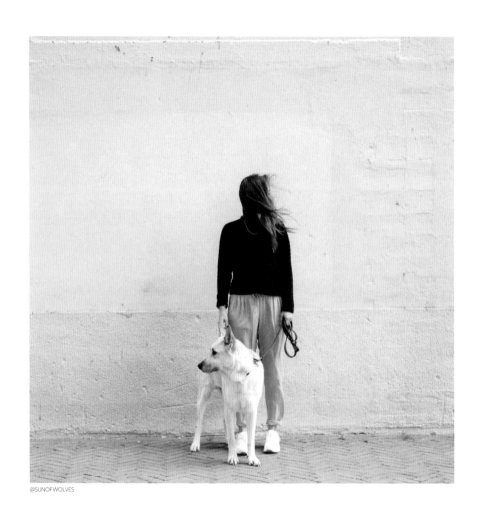

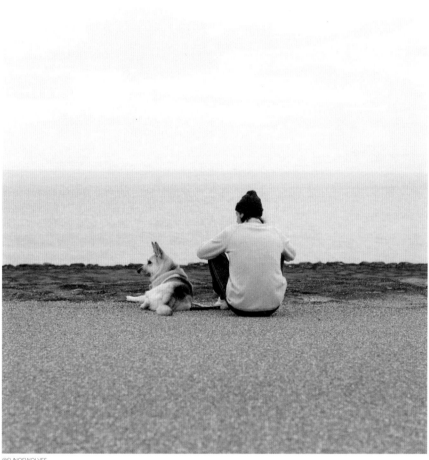

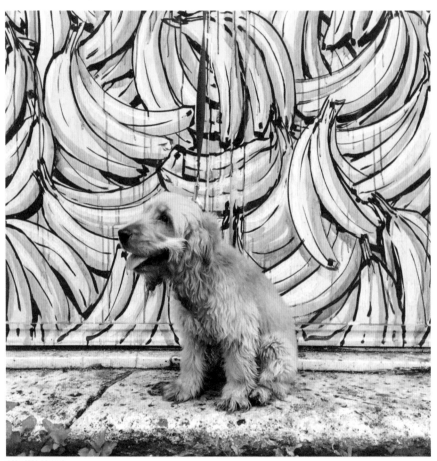

@FOLLETTO_ROMANO

"A DOOR IS WHAT A DOG IS PERPETUALLY ON THE WRONG SIDE OF."

OGDEN NASH

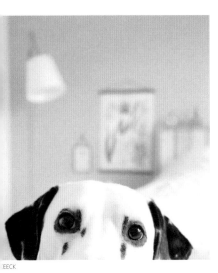

EECK

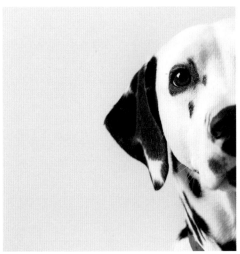

@ANNEEECK

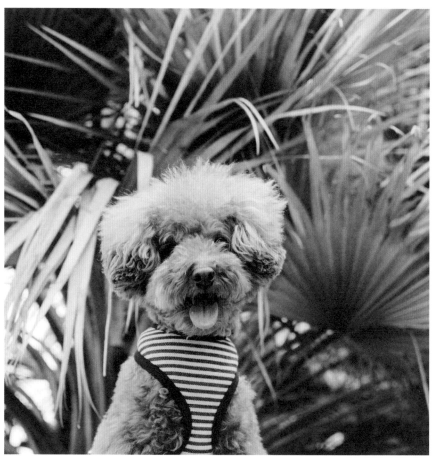

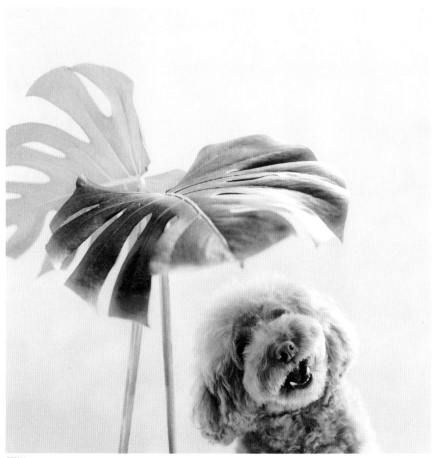

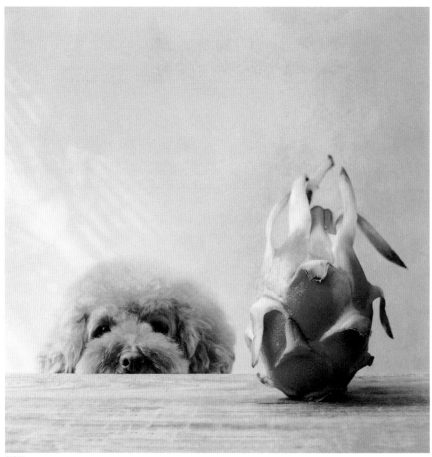

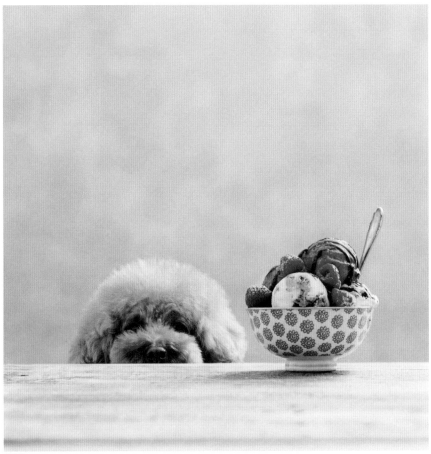

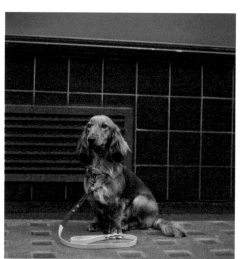

@TUNATHELONGDOG

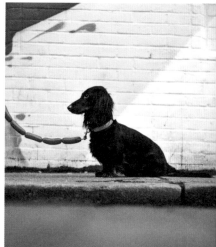

@TUNATHELONGDOG

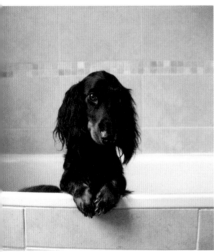

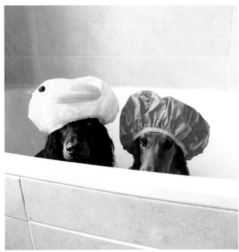

ATHELONGDOG
@TUNATHELONGDOG

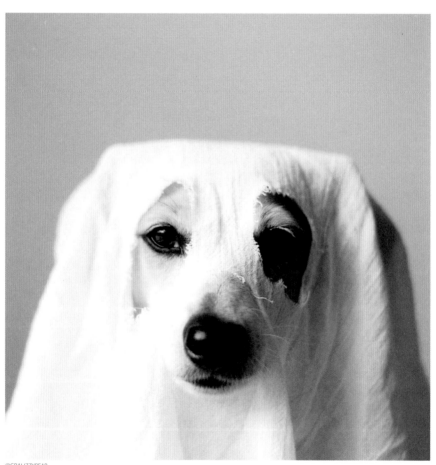

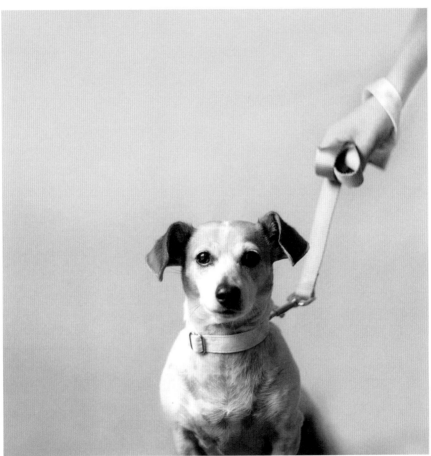

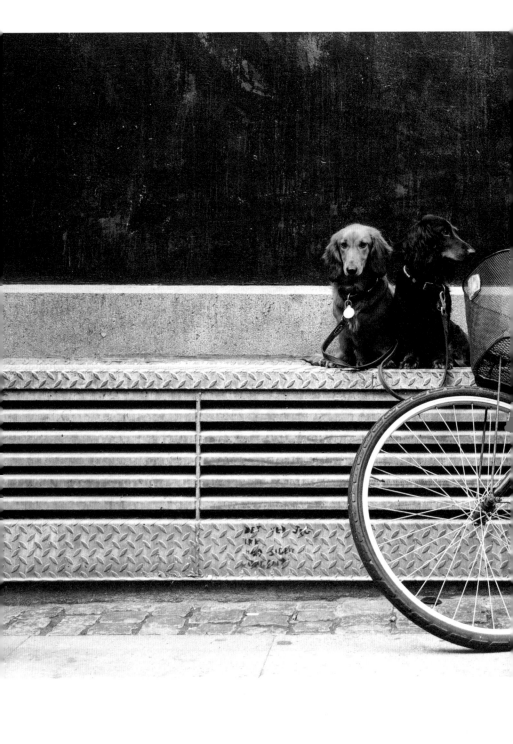

"HOUNDS FOLLOW THOSE WHO FEED THEM."

OTTO VON BISMARCK

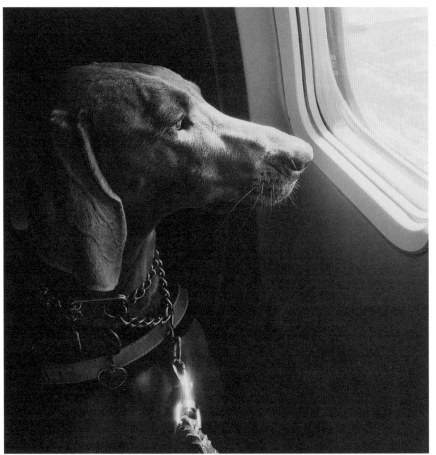

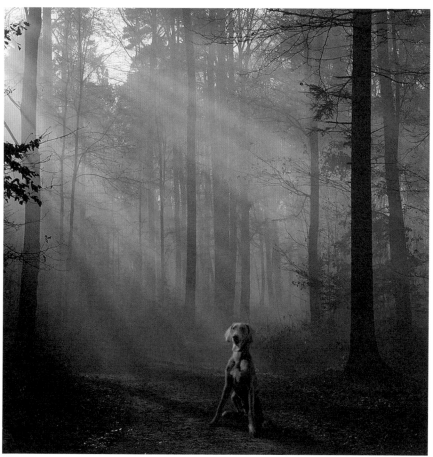

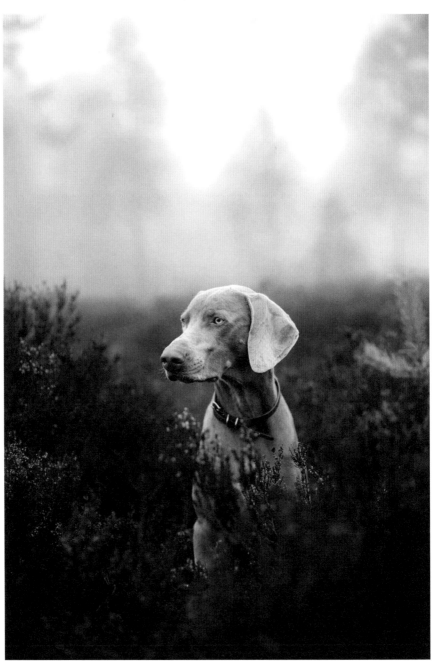

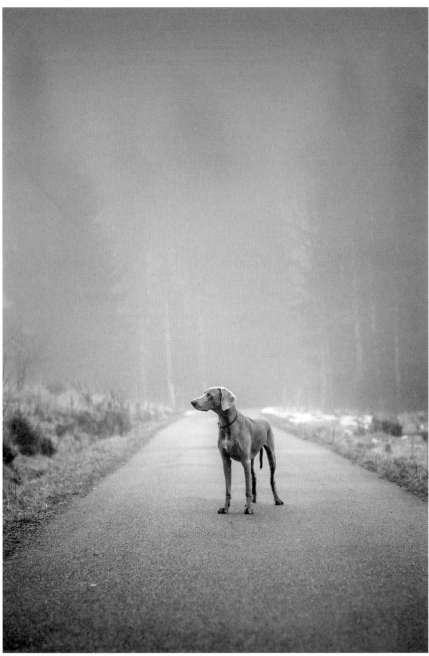

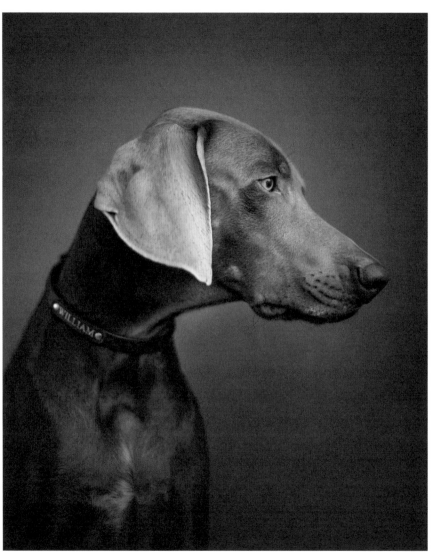

"OUTSIDE OF A DOG, A BOOK IS MAN'S BEST FRIEND. INSIDE OF A DOG IT'S TOO DARK TO READ."

GROUCHO MARX

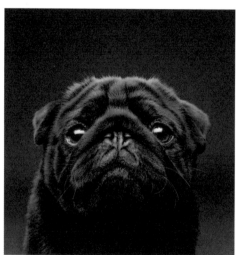

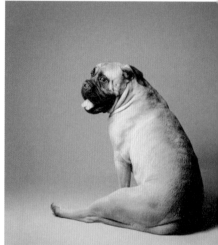

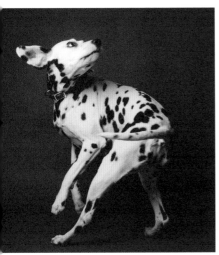

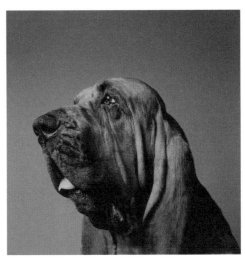

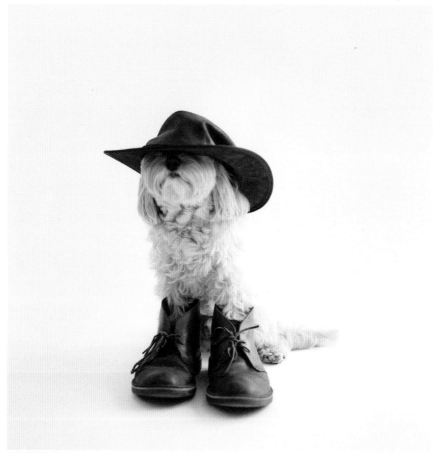

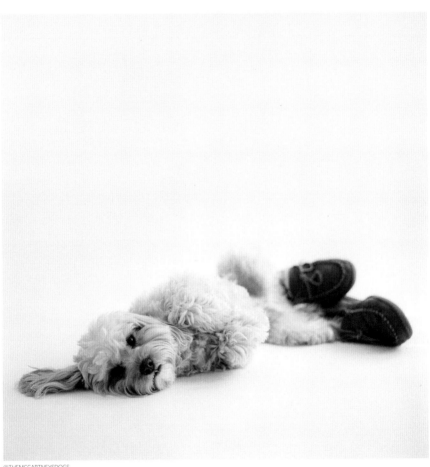

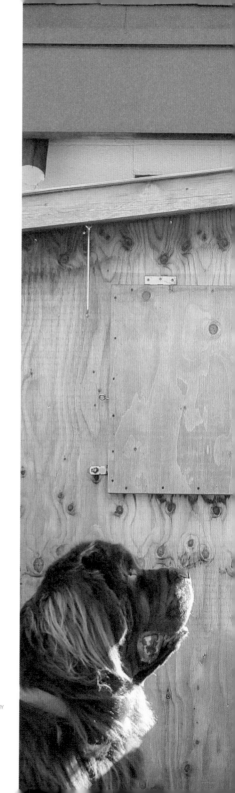

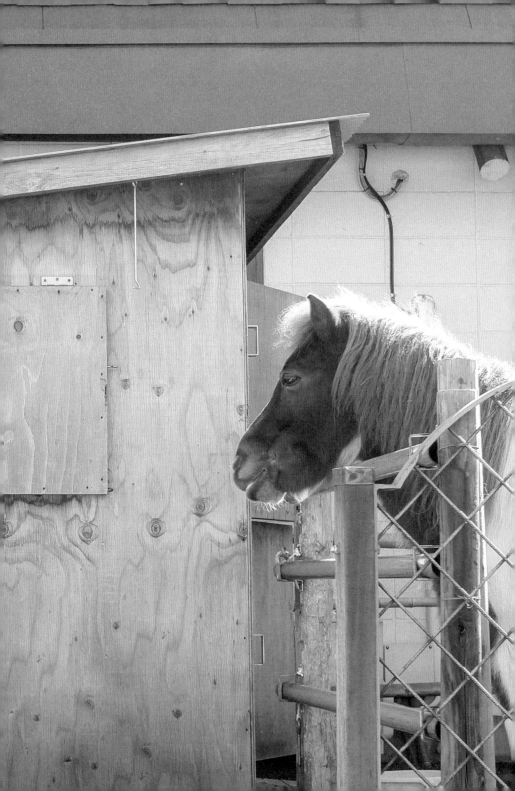

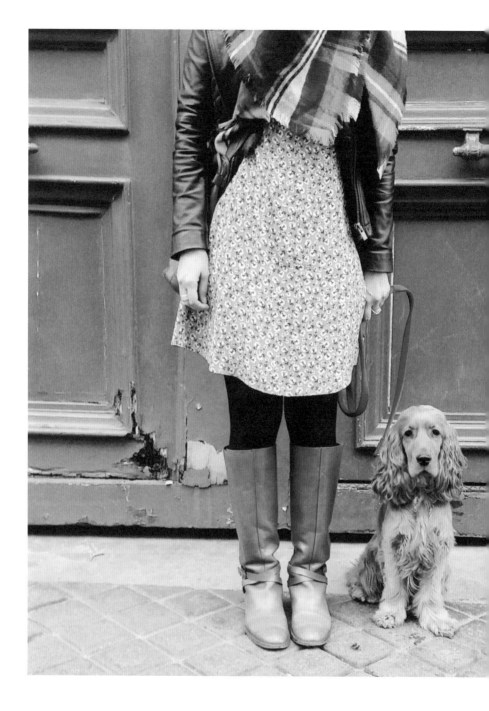

"IF YOU WANT A FRIEND, BUY A DOG. "

KEVIN O'LEARY

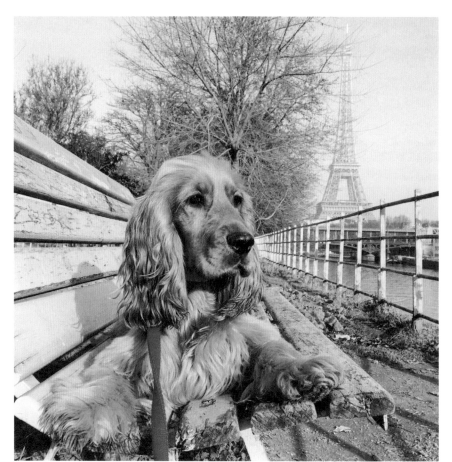

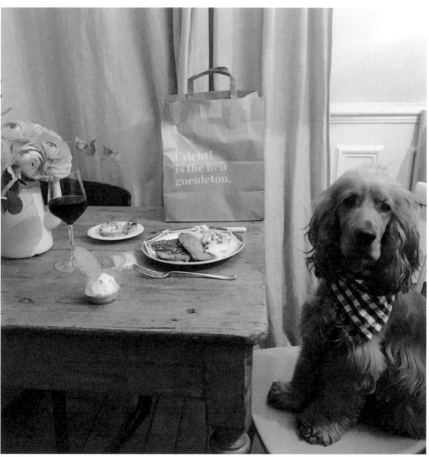

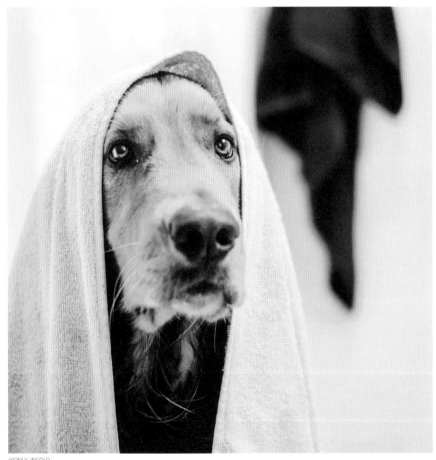

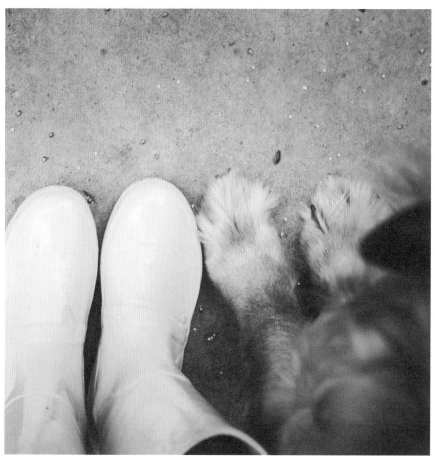

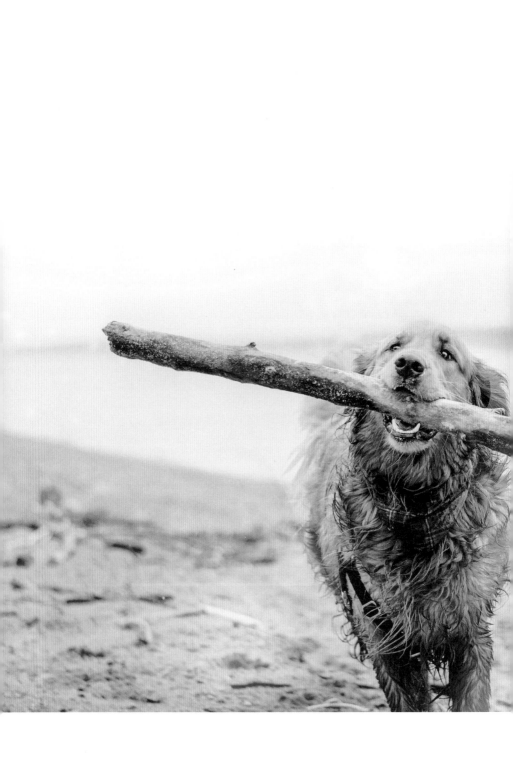

@MILESNMYLA

@MILESNMYLA

ESNMYLA

@MILESNMYLA

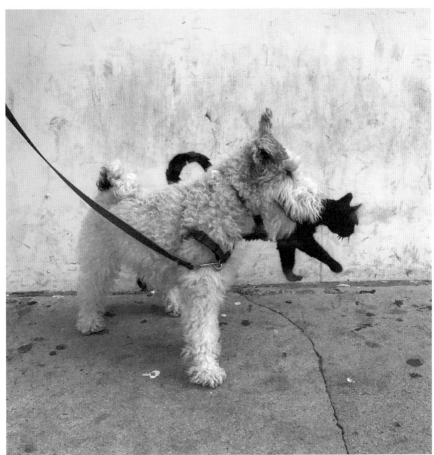

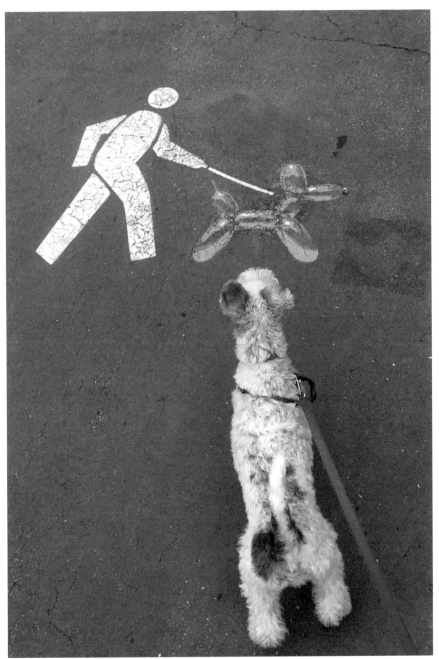

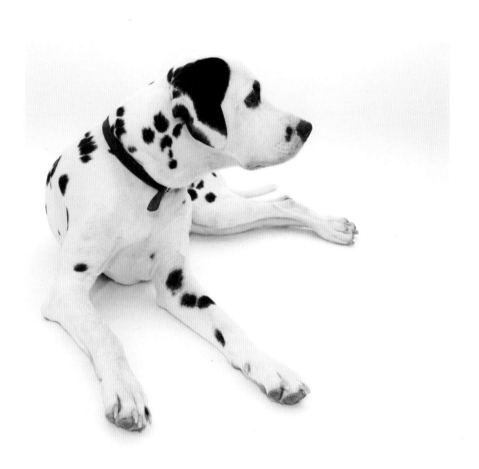

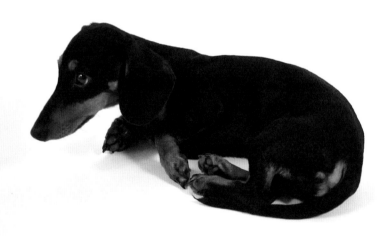

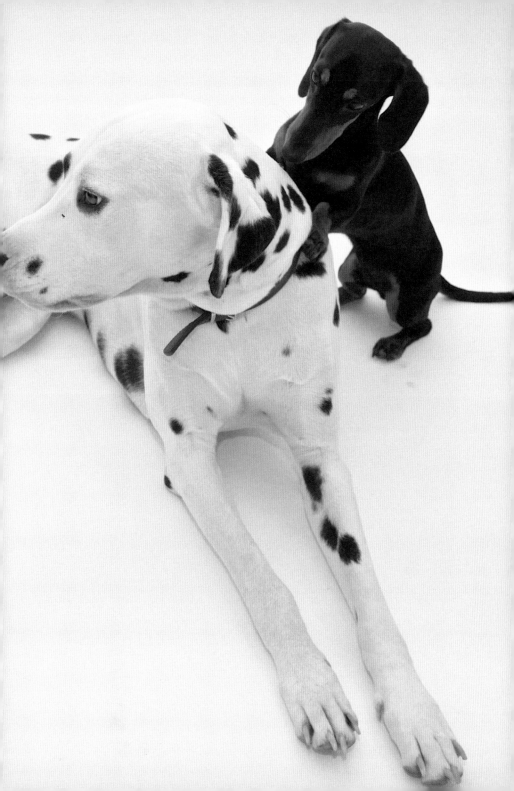

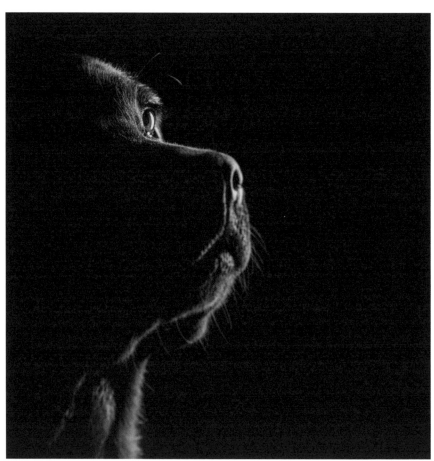

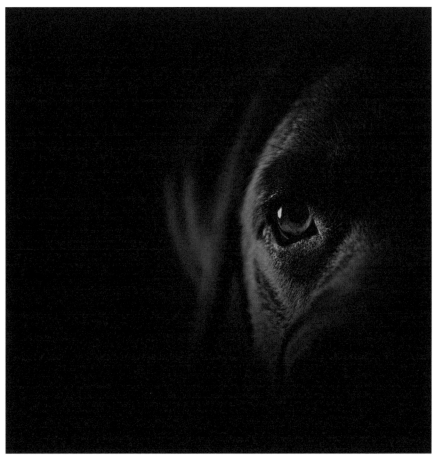

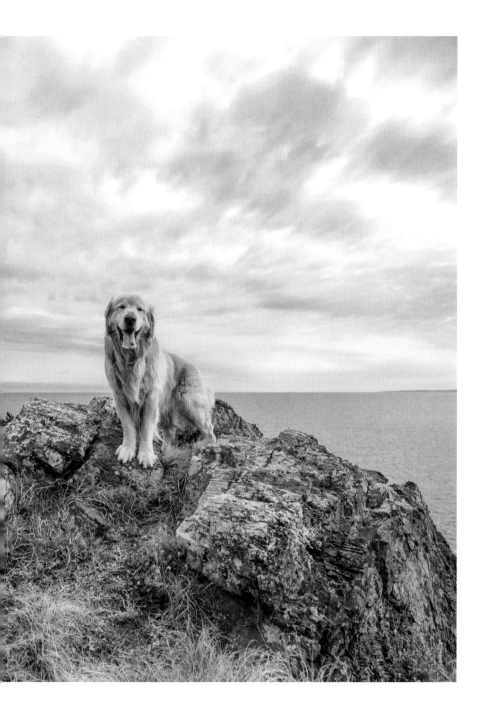

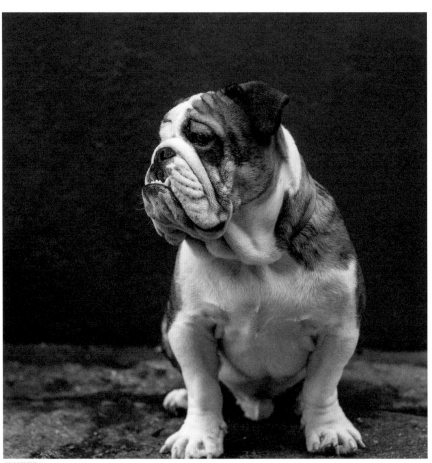

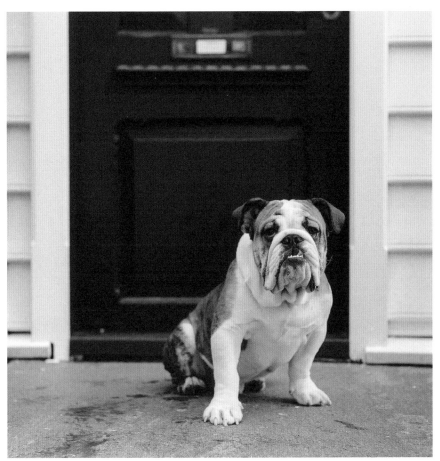

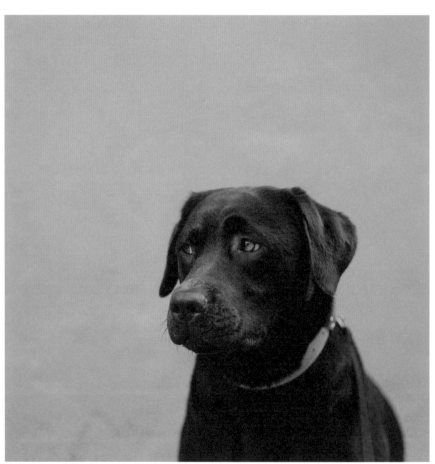

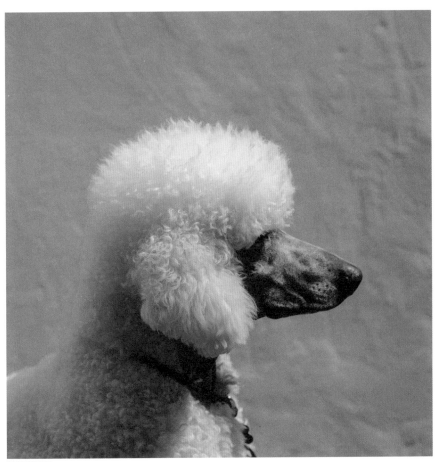

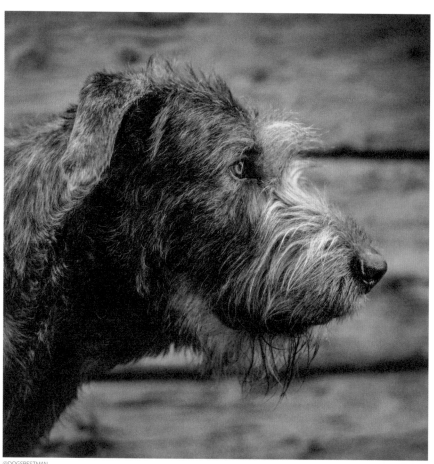

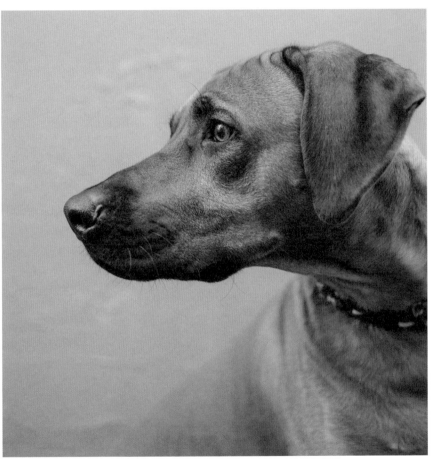

"A LOT OF SHELTER DOGS ARE MUTTS LIKE ME."

BARACK OBAMA

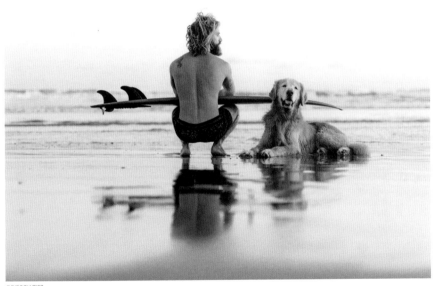

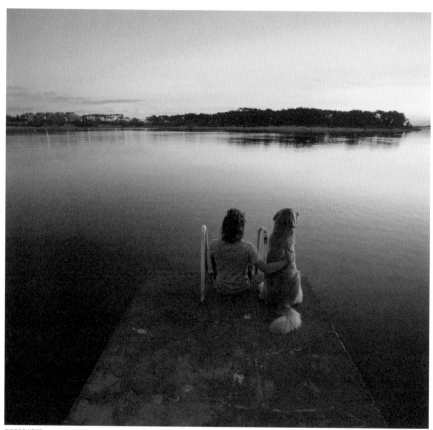

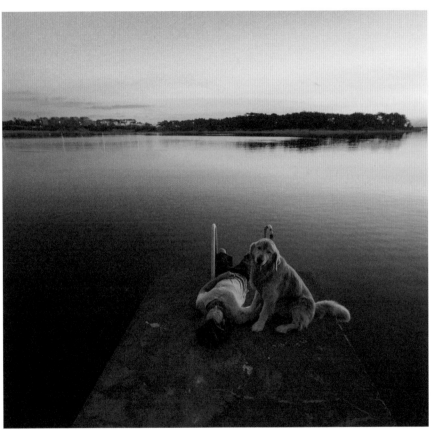

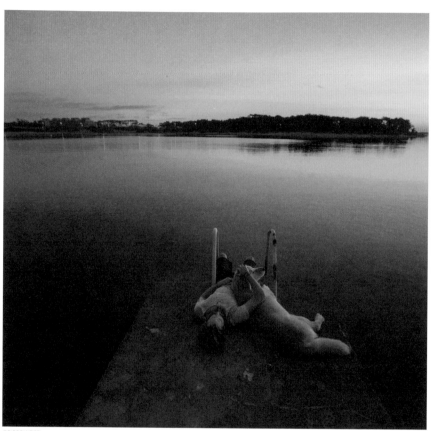

This book is
MARKED

MARKED is an initiative by Lannoo Publishers
www.marked-books.com

Sign up for our MARKED newsletter with news about new and forthcoming
publications on art, interior design, food & travel, photography and fashion
as well as exclusive offers and events.

Photo Selection/Book Design: Irene Schampaert

Cover Image:
@dea_the_dog – Photographer: Riccardo Bertoni – Art direction: Ingrid Feld

Also available:
Insta Grammar City
Insta Grammar Nordic
Insta Grammar Cats
Insta Grammar Green
Insta Grammar Graphic

If you have any questions or comments about the material in this book, please
do not hesitate to contact our editorial team: markedteam@lannoo.com

© Uitgeverij Lannoo nv, Tielt, 2017
D/2017/45/53 – NUR 652/653
ISBN: 9789401441605
www.lannoo.com

#AREYOUMARKED